The Hebridean Pocket Address Book Illustrations by Mairi Hedderwick

This edition first published in 2011 by Birlinn Limited West Newington House 10 Newington Road Edinburgh FH9 10S

www.birlinn.co.uk

Copyright @ Mairi Hedderwick 2011

All rights reserved. No part of this publication may be reproduced, stored or transmitted in any form, or by any means, electronic, mechanical or photocopying, recording or otherwise, without the express written permission of the publisher.

ISBN: 978 1 84158 988 6

British Library Cataloguing-in-Publication Data A Catalogue record for this book is available from the British Library

Printed in China

These Hebridean sketches have been garnered over a period of forty years – some whilst living on one of the islands, others as I escaped from mainland exile. Some landmarks are no more – a post box disappeared, the old pier superseded by the new, many hens long gone into the

pot. The mountains and headlands and the horizon line of the sea, however, never change – or diminish. And neither do the midges.

- Maini Hedderunck

Name		
Address		
Telephone		
Email		
Name		
Address *		
Telephone		
Email		
Name		
Address	b	
Telephone		
Email		

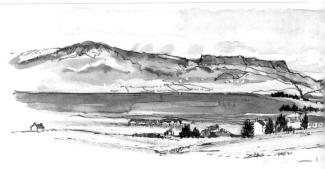

Name	
Telephone	
Name	
Name	
Telephone	
35-	
	_
To be a second of the second o	

· Staffin · Skye ·

Name
Address
Telephone
Email
Name
Address
Telephone
Email
Name
Address
Telephone
Email
Name
Address
Telephone
Email

Name	
Address	
Telephone	
Email	
Name	
Address	
Telephone	
Email	
Name	
Address	
Telephone	
Email	
Name	
Address	
Telephone	
Email	

Name	
Address	
Telephone	
Email	
Name	
Address	
Telephone	
Email	
Name	
Address	
Telephone	
Email	
Name	
Address	
Telephone	
Email	

Name

Address

B

Telephone

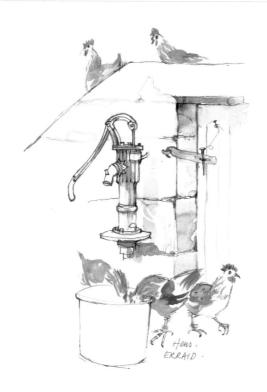

Name	
Address	
Telephone	
Email	
Name	
Address	
Telephone	
Email	
Name	
Address	
Telephone	
Email	
Name	
Address	
Telephone	
Email	

Name	
Address	
Telephone	
Email	
Name	
Address	
Telephone	
Email	
Name	
Address	
Telephone	
Email	
Name	
Address	
Telephone	
Email	

Name	
Address	
Telephone	
Email	
Name	
Address	
Telephone	
Email	

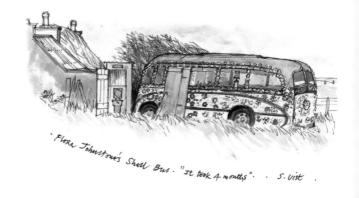

Name			
Address			
Telephone			
Email			
Name			
Address			
Telephone			
Email			
Name			
Address			
Telephone			
Email			
Name			
Address			
Telephone			
Email			

Name		
Address		
Telephone		
Email		
Name		
Address		
Telephone		
Email		
Name		
Address		
Telephone		
Email		
Name		
Address		
Telephone		
Email		

Name			
Address			
			-
			4
Telephone			
Email			
Name			
Address			
Telephone			
Email			
Name			
Address			
Telephone			
Email			
Name			
Address			
Telephone			
Email			

Name	
Address	
Telephone	
Email	
Littai	
Name	
Address	
Telephone	
Email	
Name	
Address	
Telephone	The same of the sa
Email	
	the state of the s
	and the standard
CONTRACTOR CONTRACTOR	
The section	
Total Control of the American Action	The man and a

Name
Name

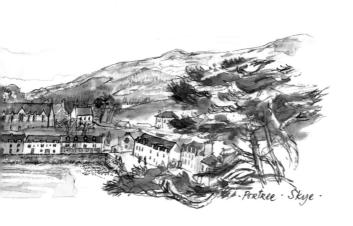

Name	
Address	
Telephone	
Email	
Name	
Address	
Telephone	
Email	
Name	
Address	
Telephone	
Email	
Name	
Address	
2	
Telephone	
Email	

Name			
Address			
Telephone			
Email			
Name			
Address			
Telephone			
Email			
Name			
Address			
Telephone			
Email			
Name			
Address	ż		
Telephone			
Email			
			1

Name
Address
Telephone
Email
Name
Address
Telephone
Email
Name
Address
Telephone
Email
Name
Address
Telephone
Email

Telephon

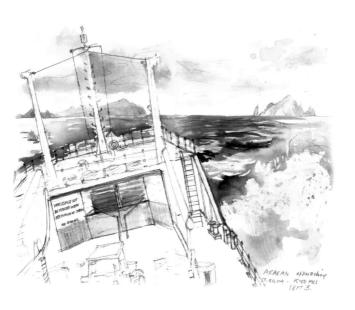

Name	
Address	
Telephone	
Email	
Name	
Address	
Telephone	
Email	
Name	
Address	
Telephone	
Email	
Name	
Address	
Telephone	
Email	

Name			
Address			
Telephone			
Email			
Name			
Address			
Telephone			
Email			
Name			
Address			
Telephone			
Email			
Name			
Address			
Telephone			
Email			

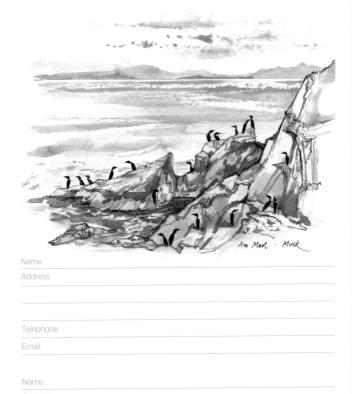

Address

relebilone

Name	
Address	
Telephone	
Email	
Name	
Address	
Telephone	
Email	
Name	
Address	
Telephone	
Email	
Name	
Address	
Telephone	
Email	

Name
Address
Telephone -
Email
Name
Address
Telephone
Email
Name
Address
Telephone
Email
Name
Address
Telephone
Email

Name	
Address	
Telephone	
Email	
Name	
Address	
Telephone	
Email	
Name	
Address	
Telephone	
Email	
Name	
Address	
Telephone	
Email	

Name	
Address	
Telephone	
Email	
Name	
Address	
Telephone	
Email	
Name	
Address	
Telephone	
Email	
Name	
Address	
Telephone	
Email	

Name			
Telephone			
Name			
Address			

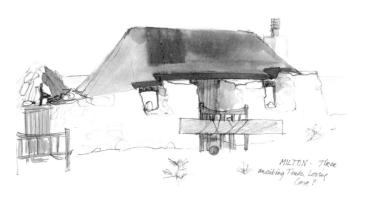

Name			
Address			
Telephone			
Email			
Name			
Address			
Telephone			
Email			
Name			
Address			e
Telephone			
Email			
Name			
Address			
Telephone			
Email			
Let I BAD			

Name	
Address	
Telephone	
Email	
Name	
Address	
Telephone	
Email	
Name	
Address	
Telephone	
Email	
Name	
Address	
Telephone	
Email	

Name	
Address	
Telephone	
Email	
Name	
Address	

Telephone

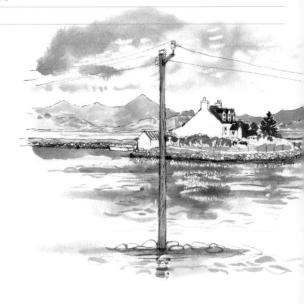

Name			
Name			
Telephone			

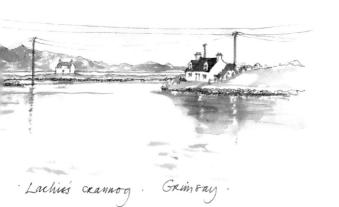

Name	
Address	
Telephone	
Email	
Name	
Address	
Telephone	
Email	
Name	
Address	
Telephone	
Email	
Name	
Address	
Telephone	
Email	

Name			
Address			
Telephone			
Email			
Name			(
Address			
Telephone			
Email			
Name			
Address			
Telephone			
Email			
Name			
Address			
Telephone			
Email			

Name			
Address			
Telephone			
Email			
Name			
Address			
Telephone			

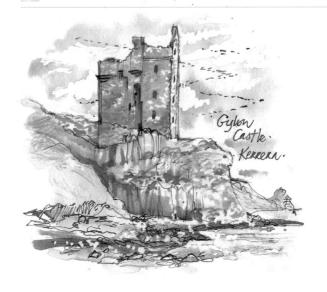

Name	
Address	
Telephone	
Email	
Name	
Address	đ
Telephone	
Email	
Name	
Address	
Telephone	
Email	
Name	
Address	
Telephone	
Email	

Name	
Address	
Telephone	,
Email	
Name	
Address	
Telephone	
Email	
Name	
Address	
Telephone	
Email	
Name	
Address	
Telephone	`
Email	

Name			
Address			
Telephone			
Email			
Name			
Address			
			-
Telephone			
Email			
Name			
Address			
Telephone			
Email			
Name			
Address			
Telephone			
Email			

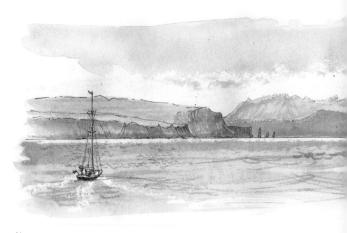

Name			
Address			
Telephone			
Email			
Name			
Address			
Telephone			
Email			

Learning Canna Canna

Address			
Telephone			
Name			
Address			
Telephone			

Name
Address
Telephone
Email
Name
Address
Telephone
Email
Name
Address
Telephone
Email
Name
Address
Telephone
Email

Name	
Address	
Telephone	
Email	
Name	
Address	
	- (
Telephone	
Name	
Address	
Telephone	
Email	
Name	
Address	
Telephone	
Email	

Name		
Address		
Telephone		
Email		
Name		
Address		
Telephone		
Email		
Name		
Address		
Telephone		
Email		
Name		
Address		
Telephone		
Email		

Name			
Name Address			
Address			

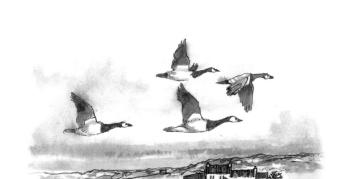

Acha : Isle of COU. The Bannacle Geere are back ...

Name	
Address	
Telephone	
Email	
Name	
Address	
Telephone	
Email	
Name	
Address	
Telephone	
Email	
Name	
Address	
Telephone	
Email	

Name	
Address	
Telephone	
Email	
Name	
Address	
Telephone	
Email	
Name	
Address	
Telephone	
Email	
Name	
Address	
Telephone	
Email	

Name			
Address			
Telephone			
Email			
Name			
Address			
Telephone			
Fmail			

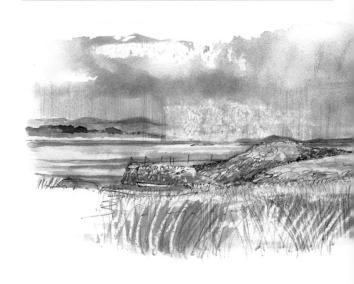

Name			
Vame			
nid.		* *	
	A SERVICE		

· GRASS Point · Locham · MULL

Name			
Address			
Telephone			
Email			
Name			
Address			
Telephone			
Email			
Name			
Address			
Telephone			
Email			
Name			
Address			
Telephone			
Email			

Name	
Address	
Telephone	
Email	
Name	
Address	
Telephone	
Email	
Name	
Address	
Telephone	
Email	
Name	
Address	
Telephone	
Email	

Ivallie			
Address			
Telephone			
Email			
Name			
Address			
Telephone			
Email			

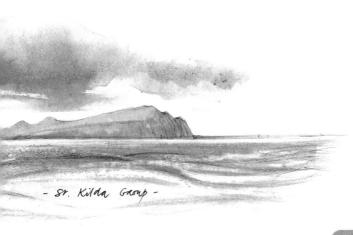

Address	
Telephone	
Email	
Name	
Address	
Telephone	
Email	

Name	
Address	
Telephone	
Email	
Name	
Address	
Telephone	
Email	
Name	
Address	
Telephone	
Email	
Name	
Address	
Telephone	
Email	

96		
80		
80.		

Name	
Address	
elephone	
Name	
Address	
elephone	
email	
	(
Name	_
Address	
Telephone	
Email	
Name	
Address	
Felephone	
Email	

Name		
Address		
Telephone		
Email		
Name		
Address		
Telephone		
Email		

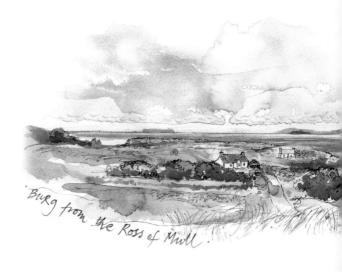

Name			
Telephone			
Email			
Name			
Telephone			

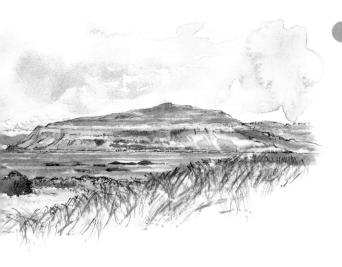

Name	
Address	
Telephone	
Email	
Name	
Address	
Telephone	
Email	
Name	
Address	
Telephone	
Email	
Name	
Address	
Telephone	
Email	

п	п		

Name	
Address	
Telephone	
Email	
Name	
Address	
Telephone	
Email	
Name	4
Address	
Telephone	
Email	
Name	
Address	
Telephone	
Email	

Name			
Address			
Telephone			
Email			
Email			
Name			
Address			
Telephone			
Email			
Name			
Address			
Telephone			
Email			

Name	
Address	
Telephone	
Email	
Name	
Address	
Telephone	
Email	
Name	
Address	
Telephone	
Email	
Name	
Address	
Telephone	
Email	

Name	
Address	
Telephone	
Email	
Name	
Address	
Telephone	
Email	
Name	
Address	
Telephone	
Email	
Name	
Address	
Telephone	
Email	

Name	
Address	
Telephone	
Email	
Name	
Address	
Telephone	
Email	
Name	
Address	
Telephone	
Email	
Name	
Address	
Telephone	
Email	

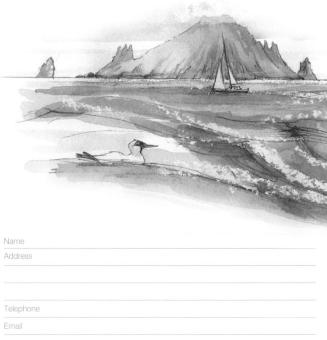

Telephone
Email

Name
Address

Telephone
Email

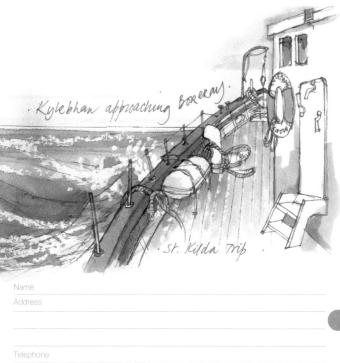

Telephone
Email

Name
Address

Name	
Address	
Telephone	
Email	
Name	
Address	
Telephone	
Email	
Name	
Address	
Telephone	
Email .	
Name	
Address	
Telephone	
Email	

Name		
Address		
Telephone		
Email		
Name		
Address		
Telephone		
Email		
Name		
Address		
		(
Television		
Telephone		
Email		
Name		
Address		
Address		
Telephone		
Email		

Name	
Address	
Telephone	
Email	
Name	
Address	
Telephone	
Email	
Name	
Address	
Telephone	
Email	
Name	
Address	
Telephone	
Email	

Address			
Telephone			
Name			
Address			
Email			

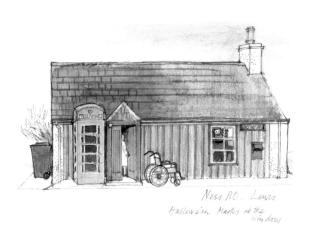

Name
Address
Telephone
Email
Name
Address
Telephone
Email
Name
Address
Telephone
Email
Name
Address
Telephone
Email

Name	
Address	
Telephone	
Email	
Name	
Address	
Telephone	
Email	
Name	
Address	
	d
Telephone	- 4
Email	
Name	
Address	
Telephone	
10100110110	

Name	
Address	
Telephone	
Email	
Name	
Address	
Telephone	
Email	

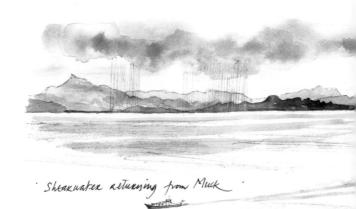

Name			
Address			
Telephone			
Email			
Name			
Address			
Telephone			

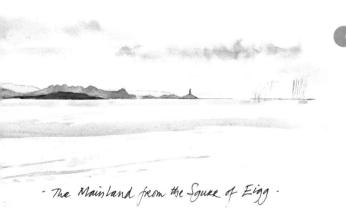

Name	
Address	
Telephone	
Email	
Name	
Address	
Telephone	
Email	
Name	
Address	
Telephone	
Email	
Name	
Address	
Telephone	
Email	

Name	
Address	
Telephone	
Email	
Name	
Address	
Telephone	
Email	
Name	
Address	
Telephone	-
Email	
Name	
Address	
Telephone	
Email	

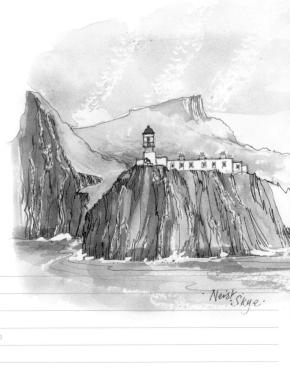

Address	· Neist Skye.
	San
Telephone	
Email	
Name	
Name Address	

Name

Telephone

-

Name	
Address	
Telephone	
Email	
Name	
Address	
Telephone	
Email	
Name	
Address	
Telephone	
Email	
0	
Name	
Address	
Telephone	
Email	

Name
Address
Telephone
Email
Name
Address
Telephone
Email
Name
Address
Telephone
Email
Name
Address
Telephone
Email

Telephone	Name	
Email Name Address Telephone Email Name Address Telephone Email Telephone Email Telephone Email	Address	
Email Name Address Telephone Email Name Address Telephone Email Telephone Email Telephone Email		
Email Name Address Telephone Email Name Address Telephone Email Telephone Email Telephone Email		
Name Address Telephone Email Name Address Telephone Email Name Address Telephone Email Name Address	Telephone	
Address Telephone Email Name Address Telephone Email Name Address Telephone Email Name Address	Email	
Address Telephone Email Name Address Telephone Email Name Address Telephone Email Name Address		
Telephone Email Name Address Telephone Email Name Address	Name	
Email Name Address Telephone Email Name Address Telephone	Address	
Email Name Address Telephone Email Name Address Telephone		
Email Name Address Telephone Email Name Address Telephone		
Name Address Telephone Email Name Address Telephone	Telephone	
Address Telephone Email Name Address Telephone	Email	
Address Telephone Email Name Address Telephone		
Telephone Email Name Address Telephone	Name	
Name Address Telephone	Address	
Name Address Telephone		
Name Address Telephone		
Name Address Telephone	Telephone	
Address Telephone	Email	
Address Telephone		
Telephone	Name	
	Address	
Email	Telephone	
	Email	

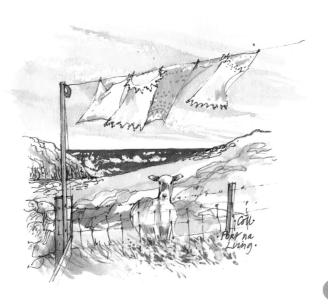

Name			
Telephone			

Name	
Address	
Telephone	
Email	
Name	
Address	
Telephone	
Email	
Name	
Address	
Telephone	
Email	
Name	
Address	
Telephone	
Email	

	98			
œ		ы		
788	=	ч		
m.				

Name	
Address	
Telephone	
Email	
Name	
Address	
Telephone	
Email	
Name	
Address	
Telephone	
Email	
	(
Name	
Address	
Telephone	
Email	

Name			
Address			
Telephone			
Email			
Name			
Address			
Telephone			
Email			

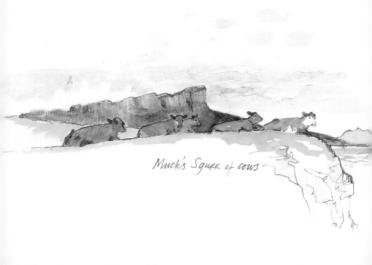

4000		
	H (0,2550)	
	0.000	

Name	
Address	
Telephone	
Email	
Name	
Address	
Telephone	
Email	
Name	
Address	
Telephone	
Email	
Name	
Address	
Telephone	
Email	

Name	
Address	
Telephone	
Email	
Name	
Address	
Telephone	
Email	
Name	
Address	
Telephone	
Email	
Name	
Address	
Telephone	
Email	

а				
	ra	71		
	ĸ	94		
	re	ъı		
	ь			

Name			
Address			
Telephone			
Email			
Name			
Address			
Telephone			
Email			
Name			
Address			
Telephone			
Telephone Email			
Email			
Email Name			
Email Name			
Email Name			

Name	
Address	
Telephone	
Email	
Name	
Address	
Telephone	
Email	• .
Name	
Address	
Telephone	
Email	
Name	
Address	
71001000	
Telephone	
Email	

The state of the s	
Rum & Kylebran at the New Fier	

Telephone			

Name	
Address	
Telephone	
Email	
Name	
Address	
Telephone	
Email	
Name	
Address	
Telephone	
Email	
Name	
Address	
Telephone	
Email	

ra		
N	58	
Ľ	40	

Name	
Address	
Telephone	
Email	
Name	
Address	
Telephone	
Name	
Address	
Telephone	
Email	
Name	
Address	
Telephone	
Email	

Name	
Address	
Telephone	
Email	
Name	
Address	
Telephone	
Email	
Name	
Address	
Telephone	
Fmail	

Name			
Address			
Telephone			
Email			
Litte			
Name			
Address			
Telephone			
Email			
Name			
Address			
Telephone			
Email			
Litidii			
Name			
Address			6
			-
Telephone			

Name	
Address	
Telephone	
Email	
Name	
Address	
Telephone	
Email	
Name	
Address	
Telephone	
Email	
Name	
Address	
Telephone	
Email	

Address		
Telephone		
Email		
CITIAII		
Name		
Address		
Telephone		
Email		
Name		
Address		
Telephone		
Email		
Name		
Address		
Address		
Telephone		
Email		

IJ

Name	
Address	
Telephone	
Email	
Name	
Address	
Telephone	
Email	
Name	
Address	
Telephone	
Email	
Name	
Address	
Telephone	
Email	

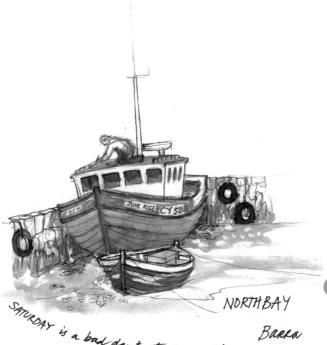

SATURDAY is a bad day to start anything

Name
Address
Telephone
Email
Name
Address
Telephone
Email
Name
Address
Telephone
Email
Name
Address
Telephone
Email

Name		
Address		
Telephone		
Email		
Name		
Address		
Telephone		
Email		
Name		
Address		
Telephone		
Email		
Name		
Address		
Telephone		
Email		

Name
Address
Telephone
Email
Name
Address
Telephone
Email
Name
Address
,
Telephone
Email
Name
Address
-
Telephone
Email

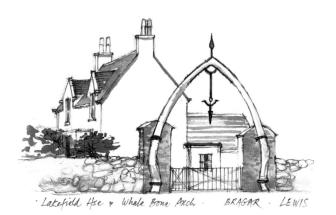

Address			
Telephone			
Email			
Name			
Address			
Telephone			

JV

Name	
Address	
Telephone	
Email	
Name	
Address	
Telephone	
Email	
Name	
Address	
Telephone	
Email	
Name	
Address	
Telephone	
Email	

Name	
Address	
Telephone	
Email	
Litte	
N	
Name	
Address	
Telephone	
Email	
Name	
Address	
Telephone	
Email	
Name	
Address	
Telephone	W
Email	

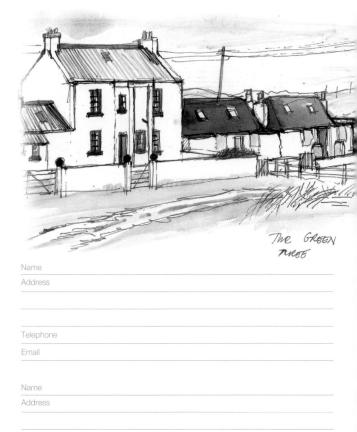

Telephone Email

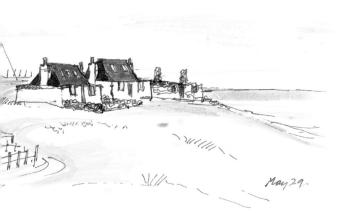

Address			
Telephone			
Email			
Name			
Address			
Telephone			

Email

Name	
Address	
Telephone	
Email	
Name	
Address	
Telephone	
Email	
Name	
Address	
Telephone	
Email	
Name	
Address	
Telephone	
Email	

Name			
Address			
Telephone			
Email			
Name			
Address			
Telephone			
Email			
Name			
Address			
Telephone			
Email			
Name			
Address			
Telephone			

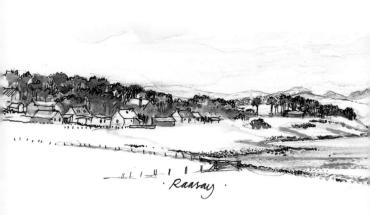

Name			
Address			
Telephone			
Email			
Name			
Address			
Telephone			
Email			

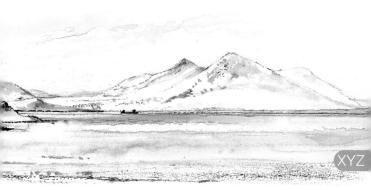

Name	
Address	
Telephone	
Email	
Name	
Address	
Telephone	
Email	
Name	
Address	
Telephone	
Email	
Name	
Address	
Telephone	
Email	